NEW CANAAN, CONNECTICUT
THE NEXT STATION
TO HEAVEN

To order additional copies of this book, contact:
Xlibris Corporation
1-888-795-4274
www.Xlibris.com
Orders@Xlibris.com

Acknowledgements

Thank you to Kelly McGee, Tom Swick, Andrea Hutter, Connie Brown, Miles Wallace, and Bruce Pauley Tree Care. Also with gratitude to Michelle, Cristin, Katie, Megan, Liza and her family.

Introduction

In 1967, as a teenager, I moved with my family to New Canaan, Connecticut. When I left for college I remember thinking that I might never return to this small town that had become my home. Yet, in time, I was drawn back. Recently I purchased my mother's house, along with its memories.

What follows are glimpses of life in a place I again call home—a place deserving of its nickname, "The Next Station to Heaven."

WINTER

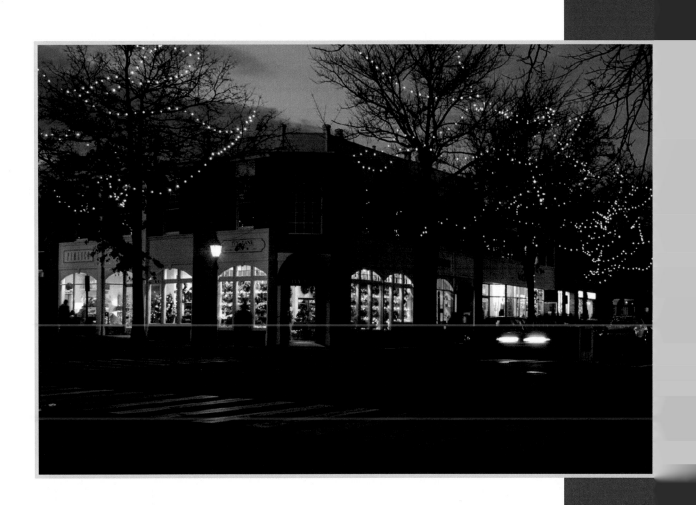

Main and Elm

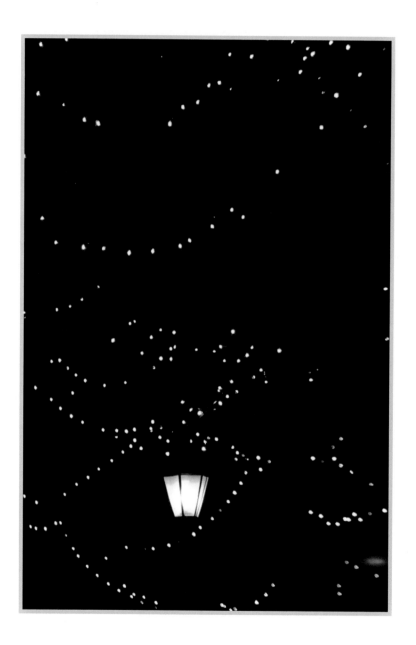

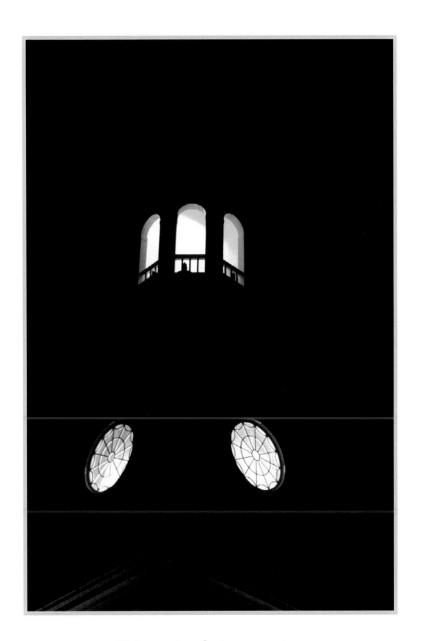

First Church,
of Christ Scientist

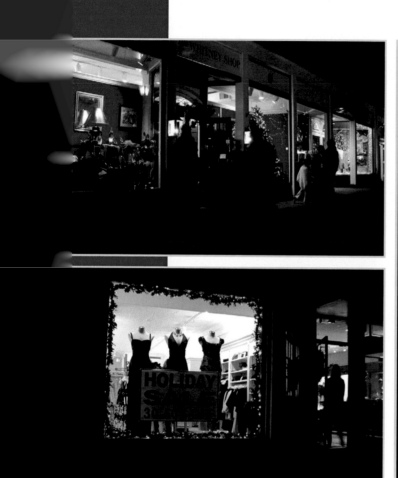

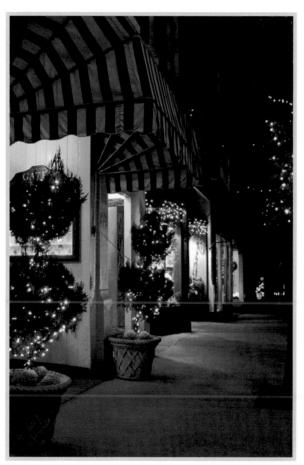

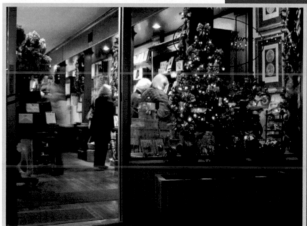

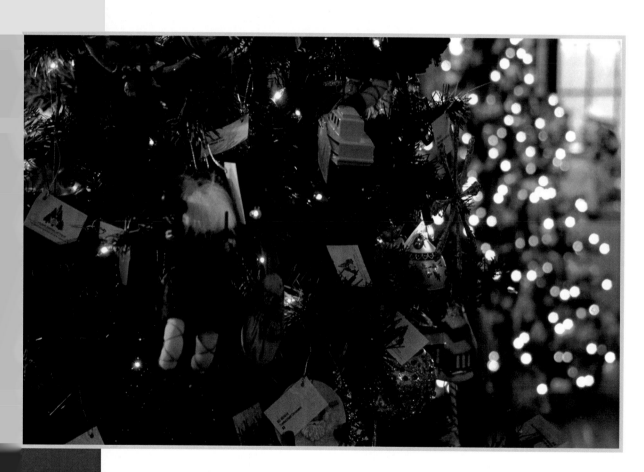

The Festival of Trees

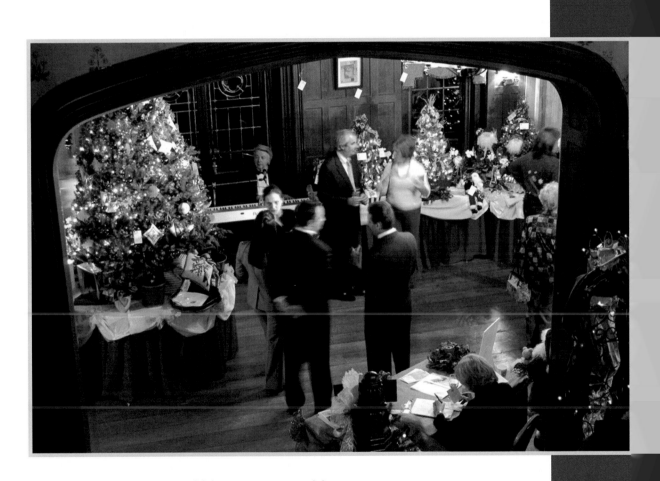

Waveny House

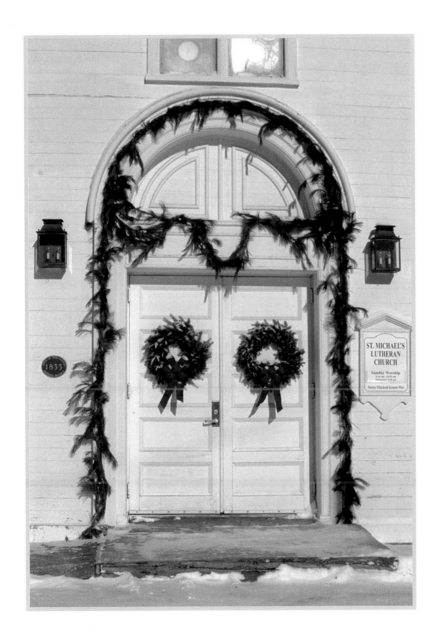

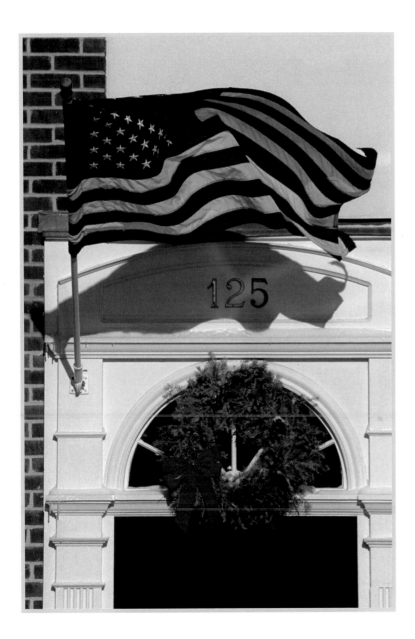

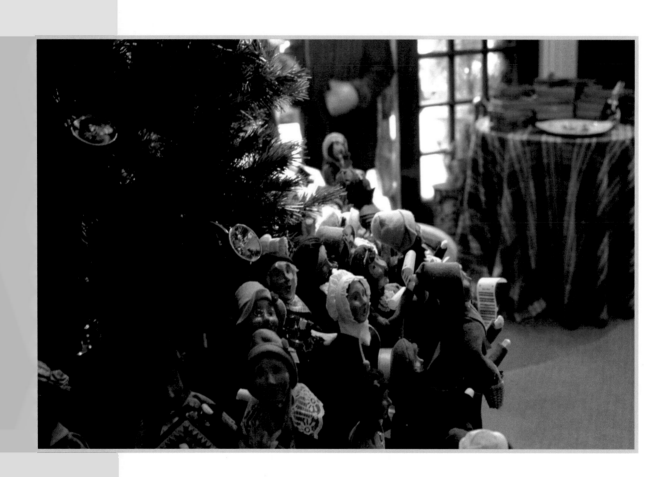

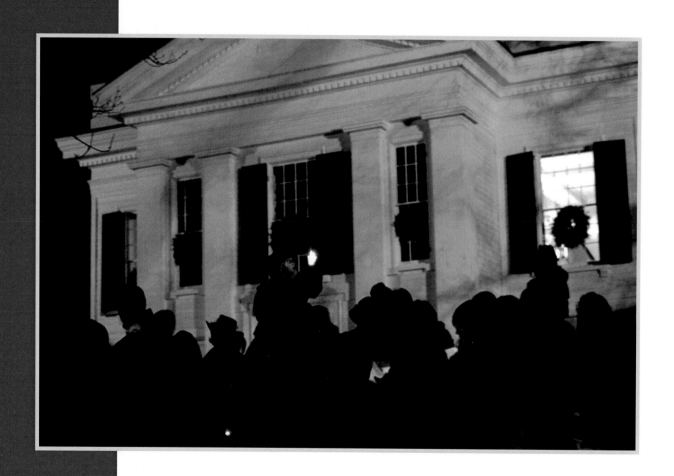

The Community
Baptist Church

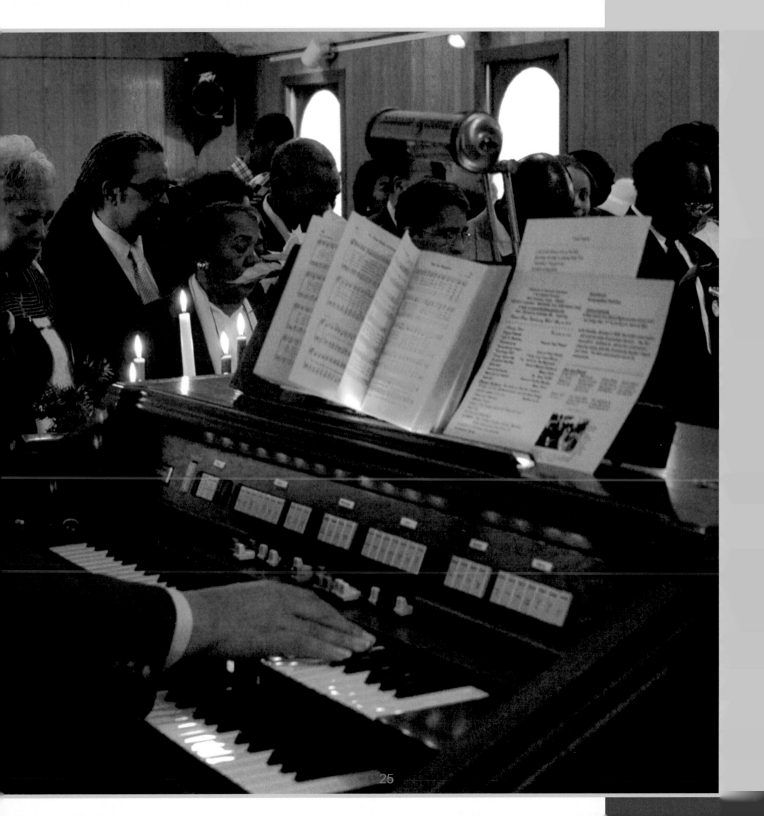

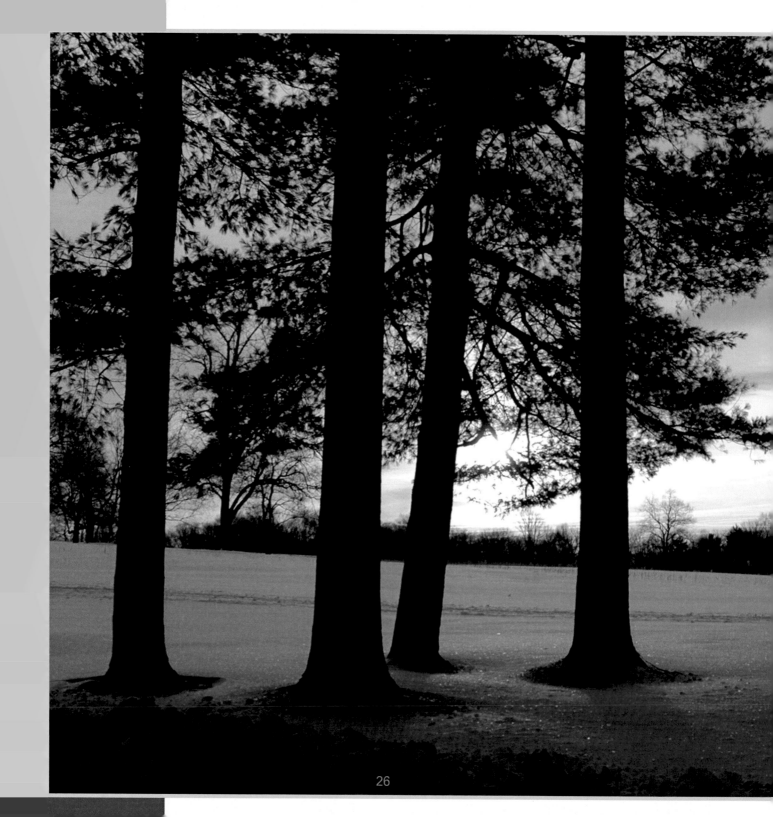

Waveny
Park

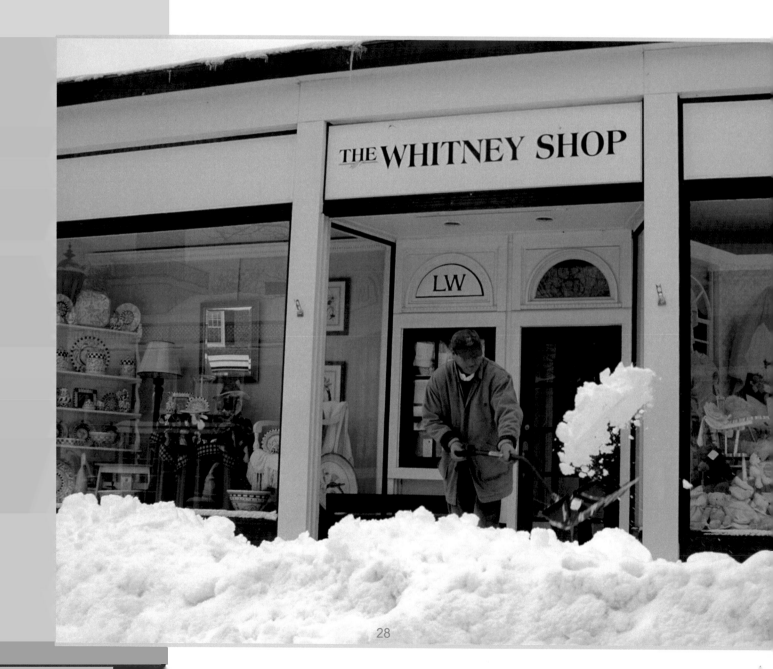

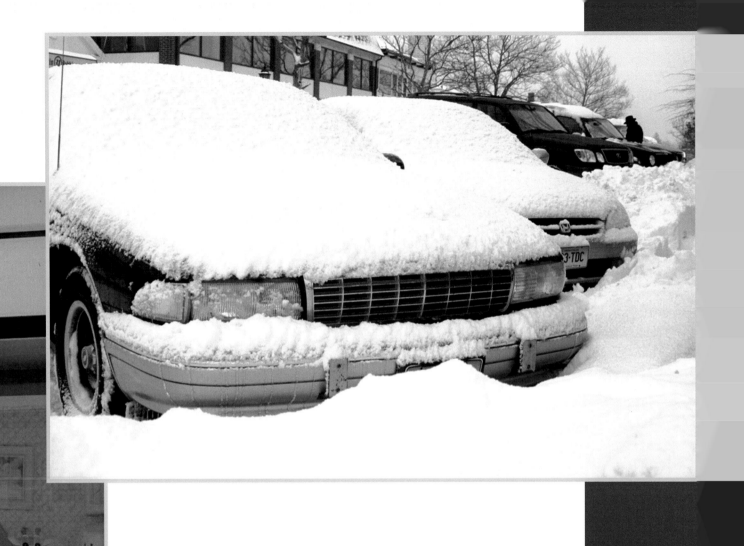

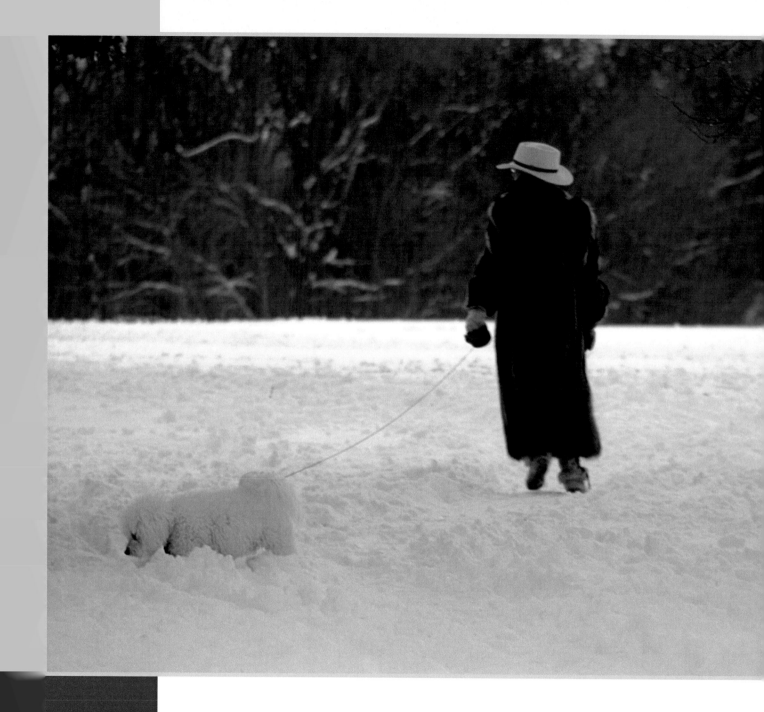

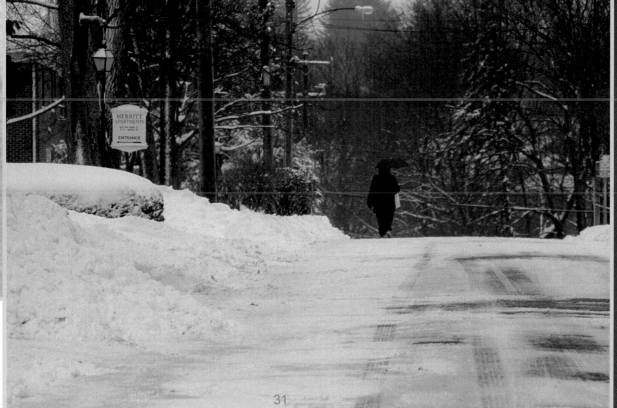

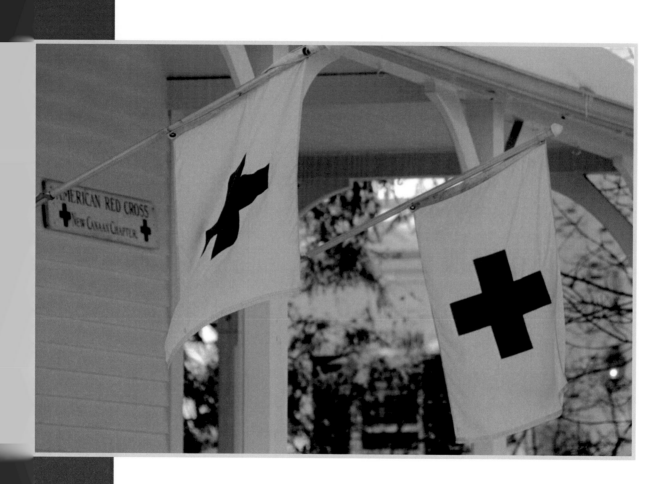

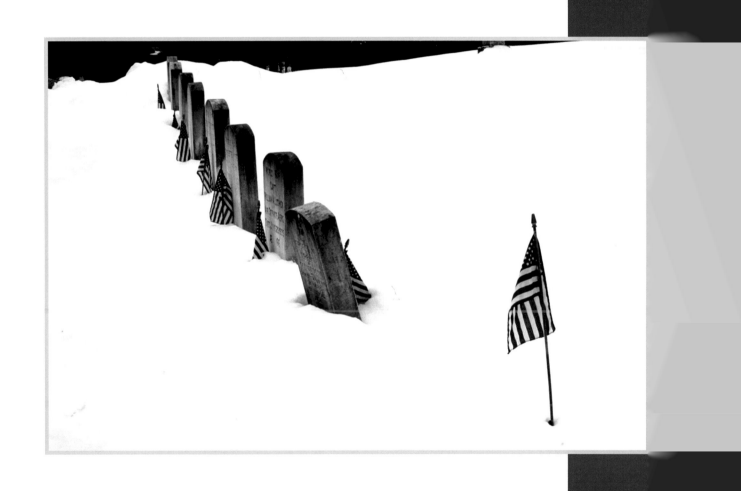

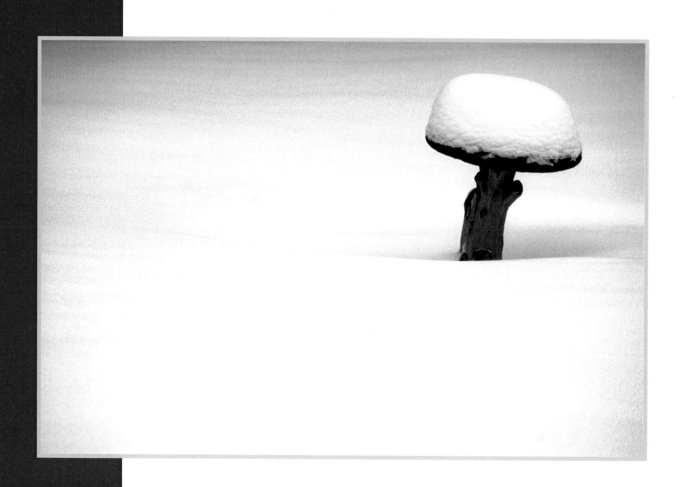

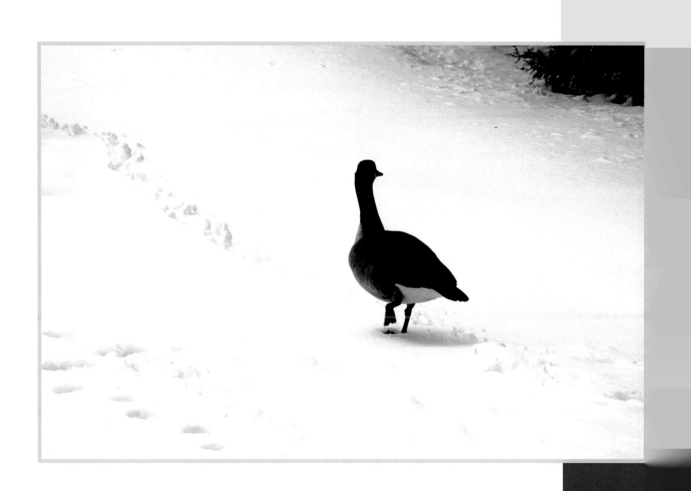

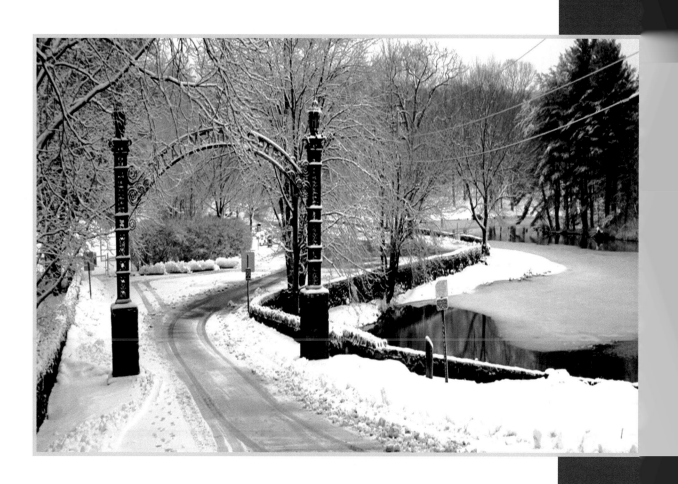

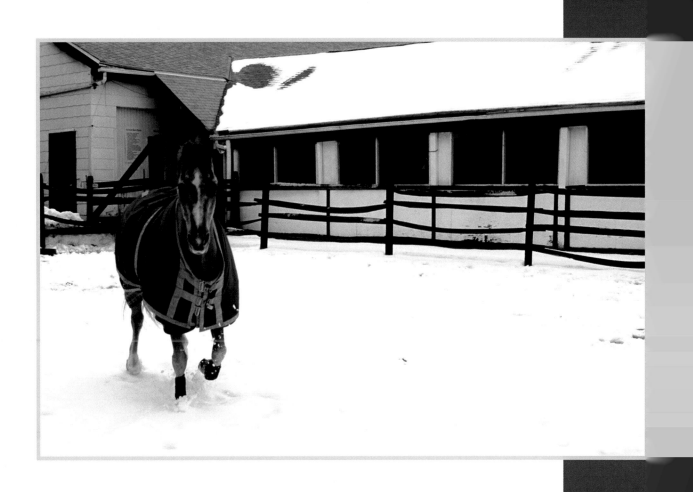

SPRING

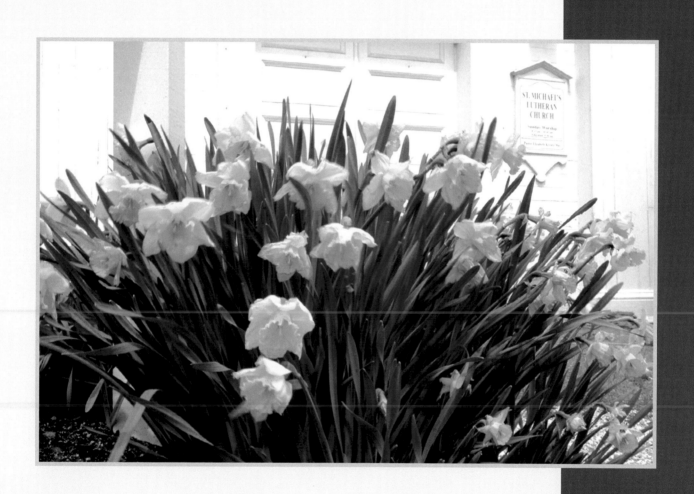

The May Fair,
St. Mark's Church

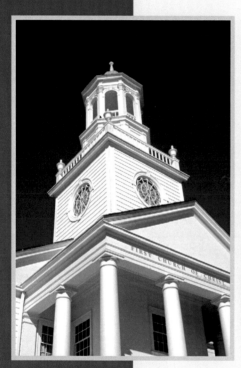

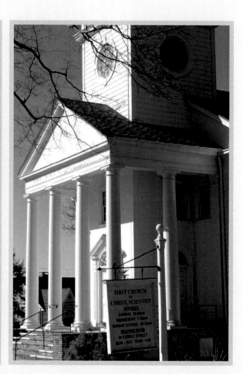

God's Acre

St. Michael's
Lutheran Church

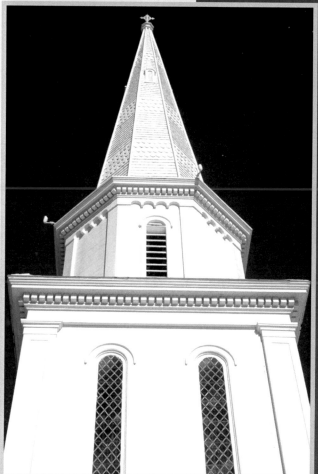

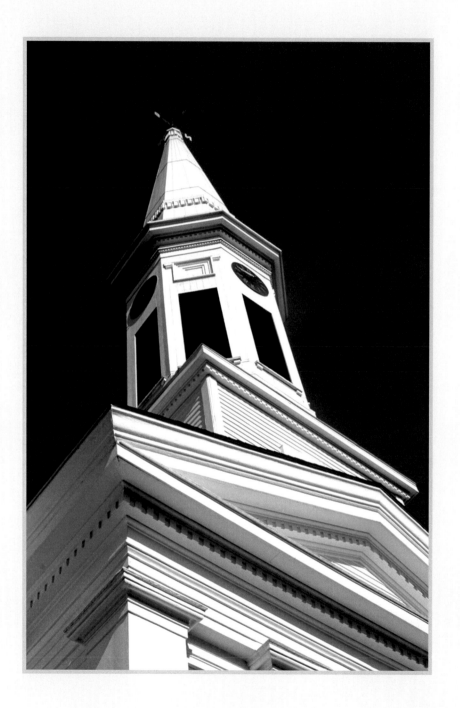

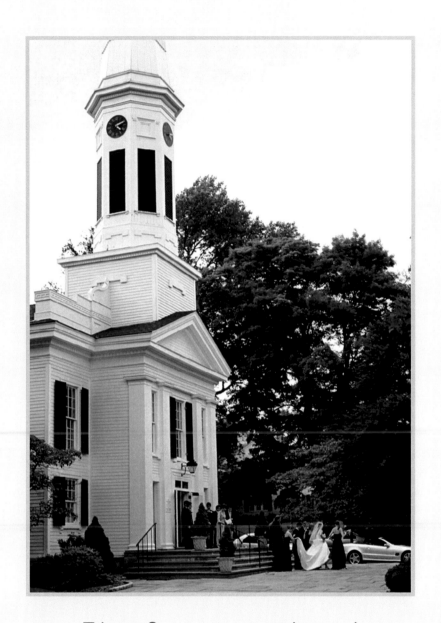

The Congregational
Church of New Canaan

SUMMER

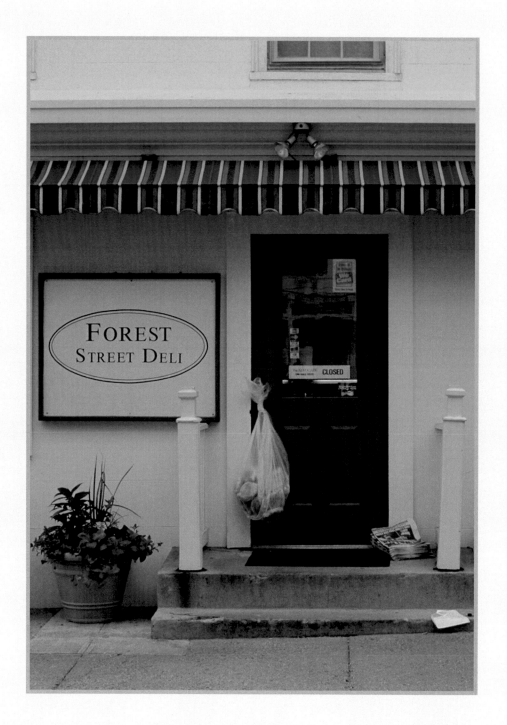

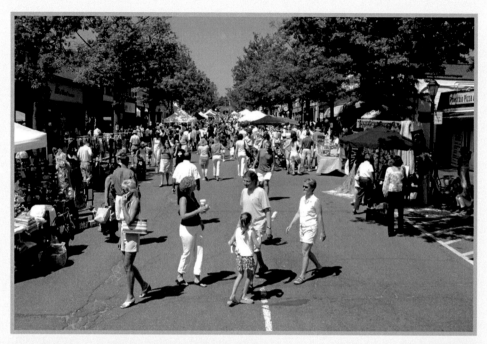

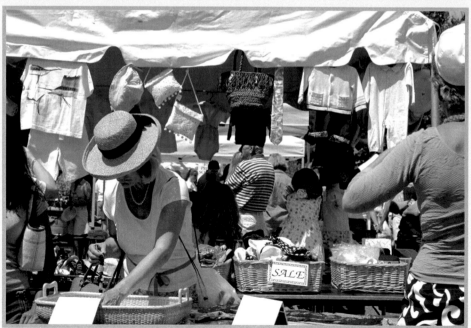

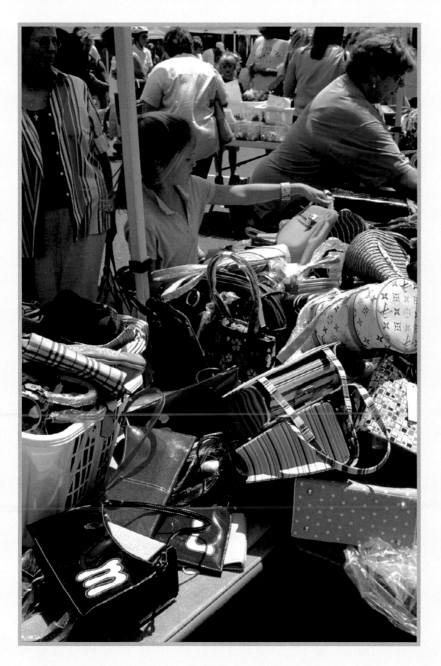

Sidewalk Sale

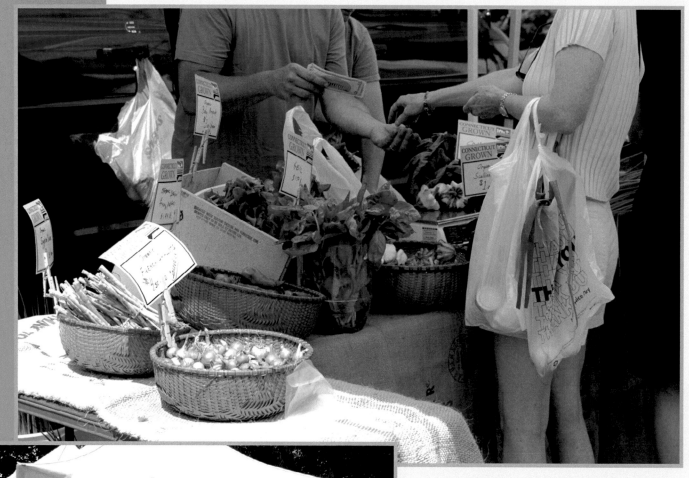

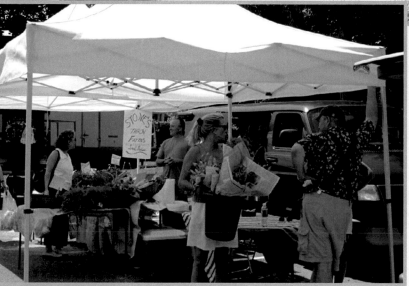

Farmer's
Market

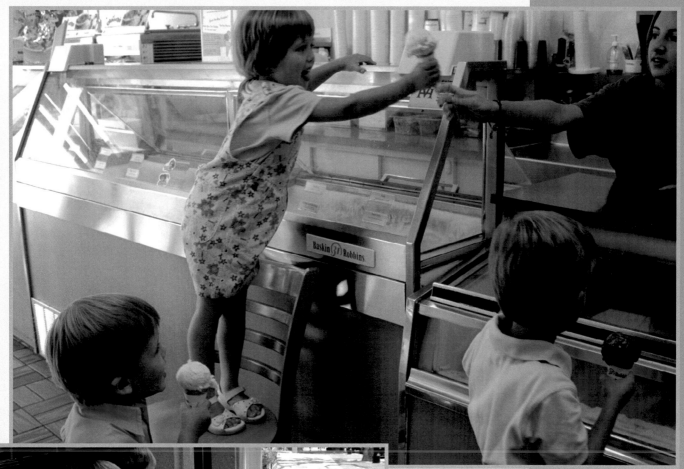

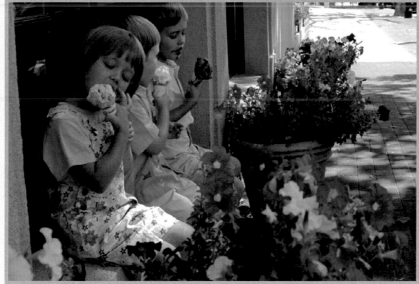

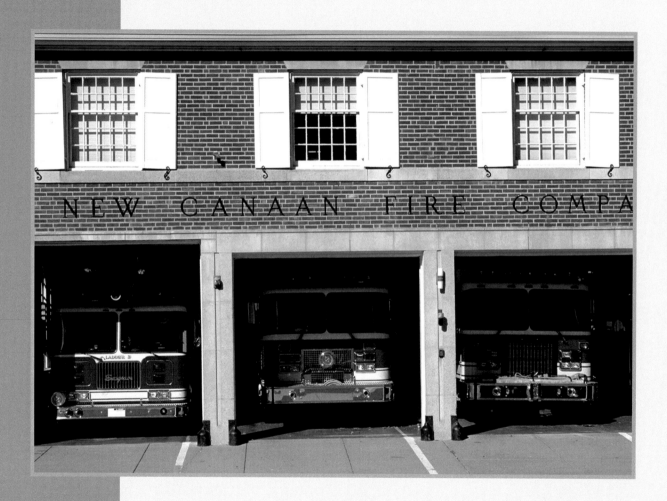

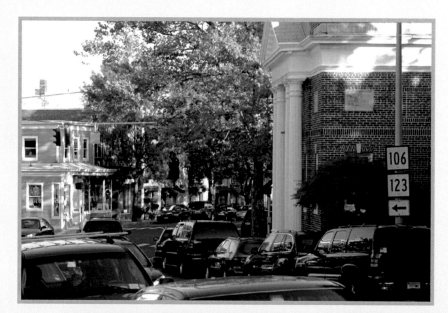

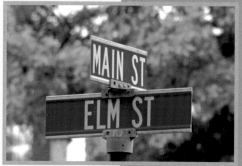

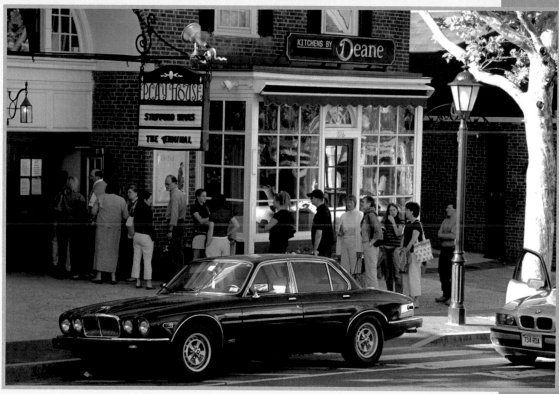

Elm Street

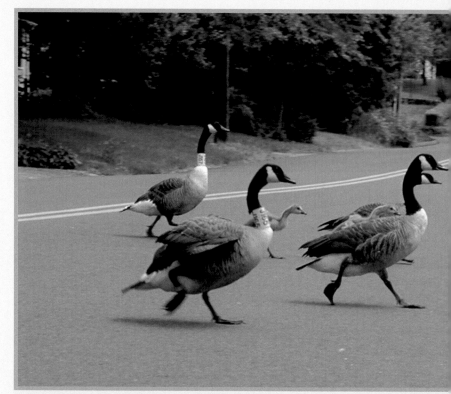

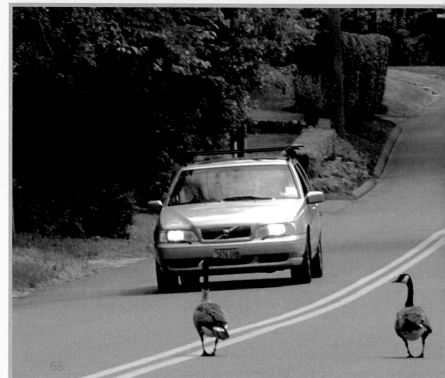

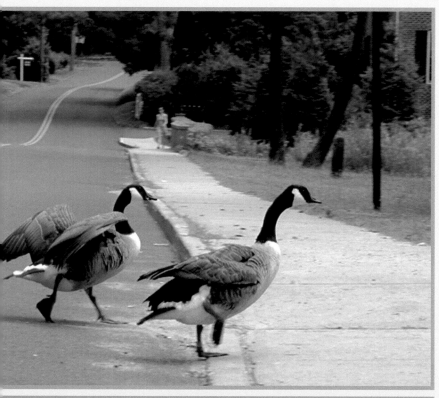

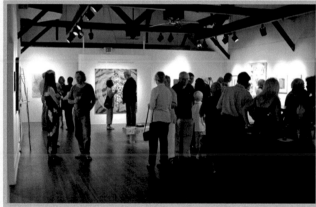

FALL

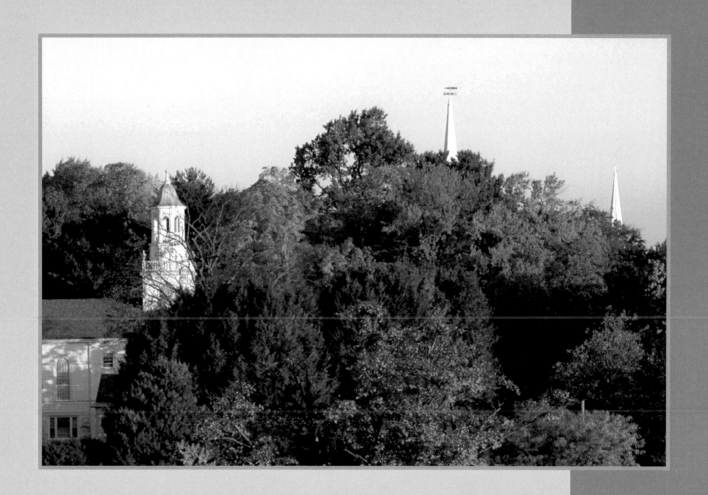

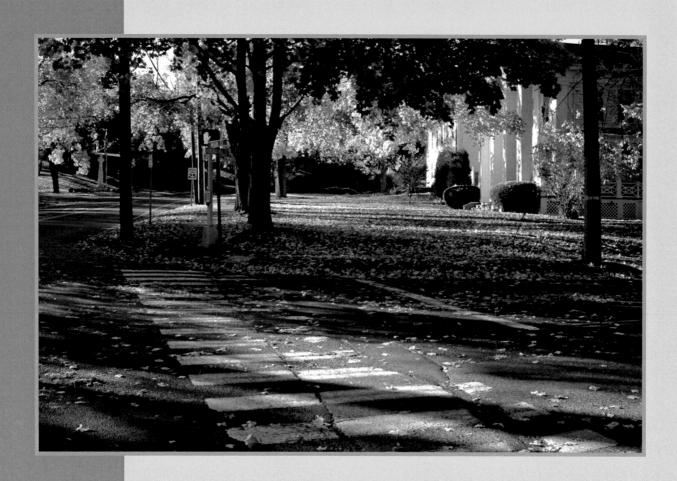

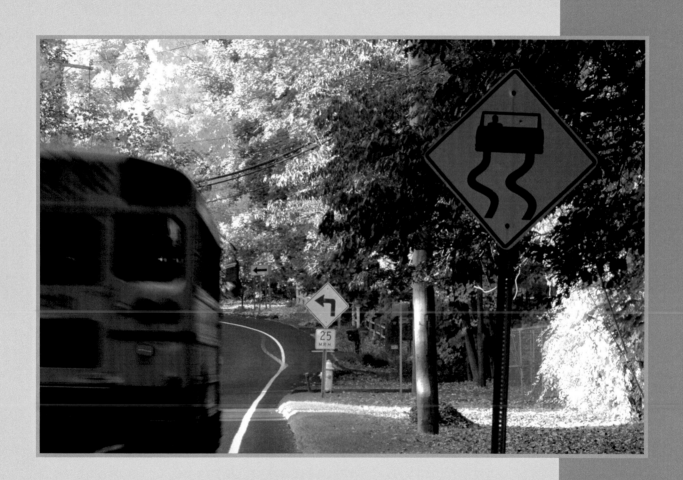

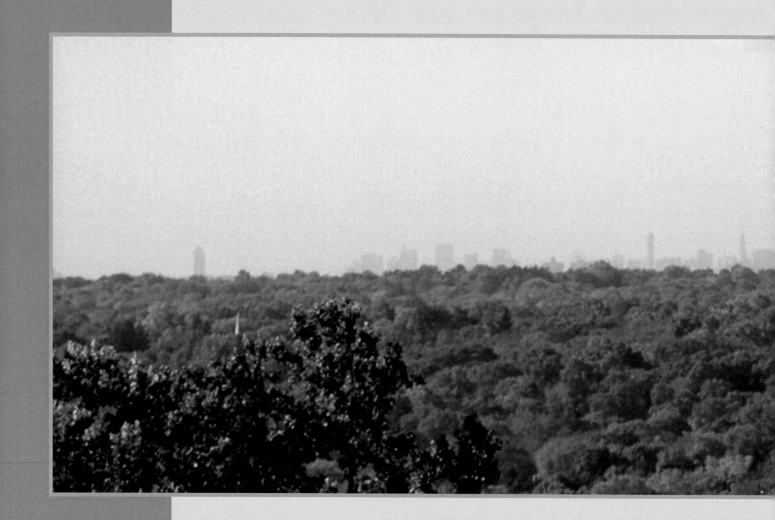

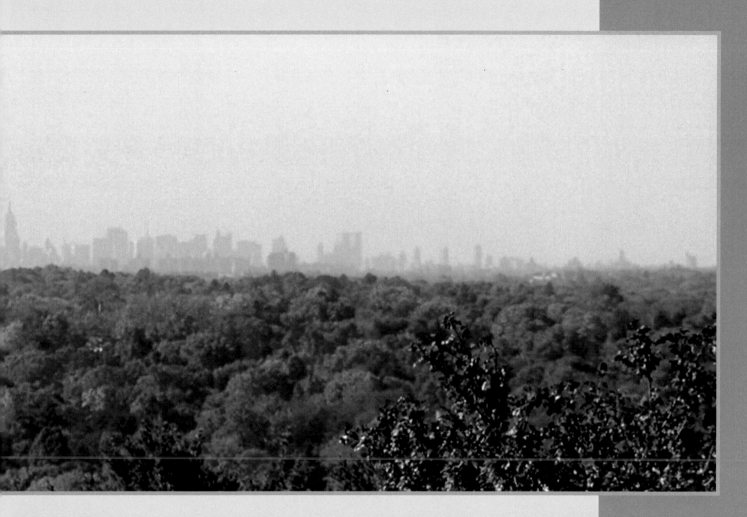

Waveny Park Tree Tops

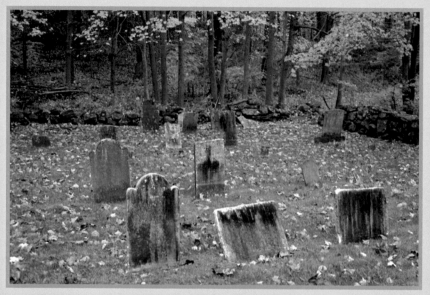

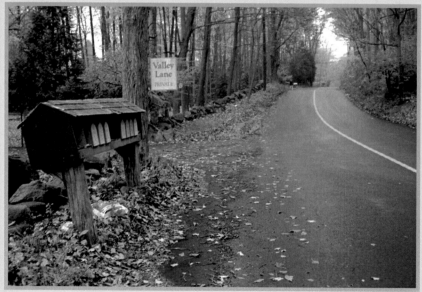

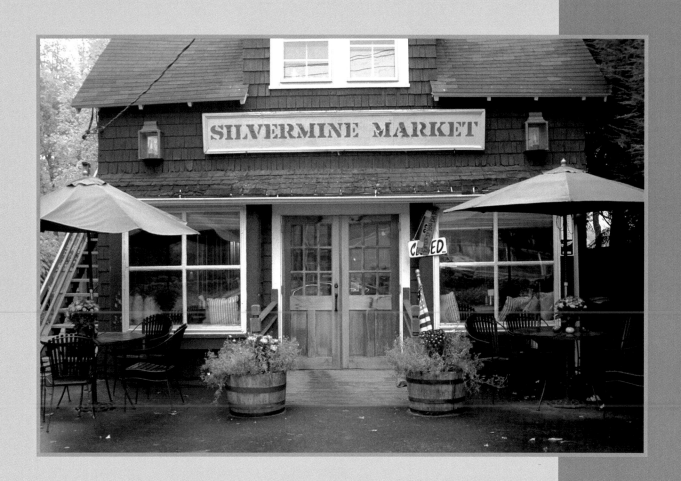

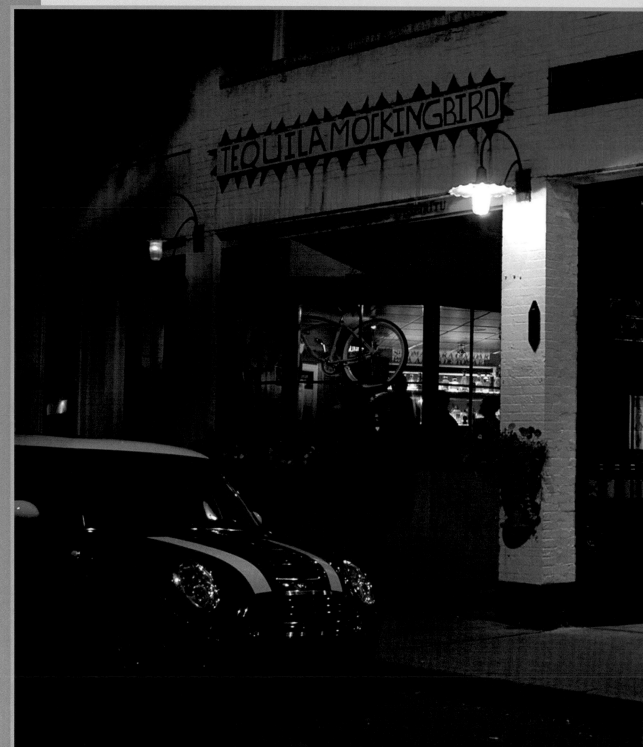

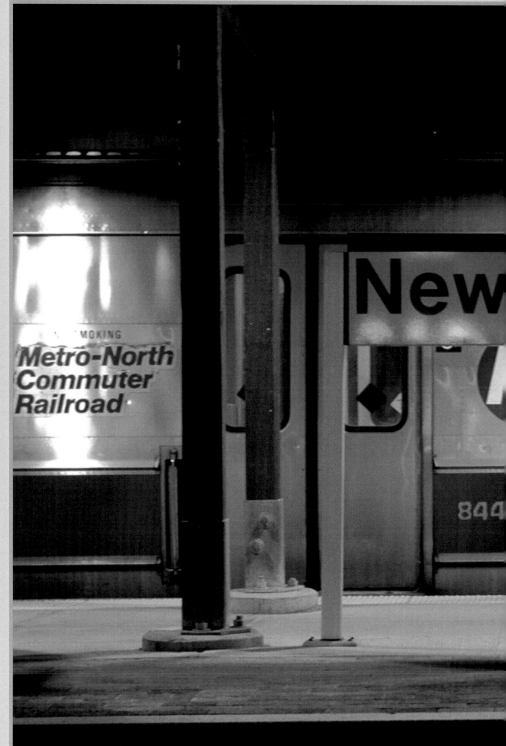

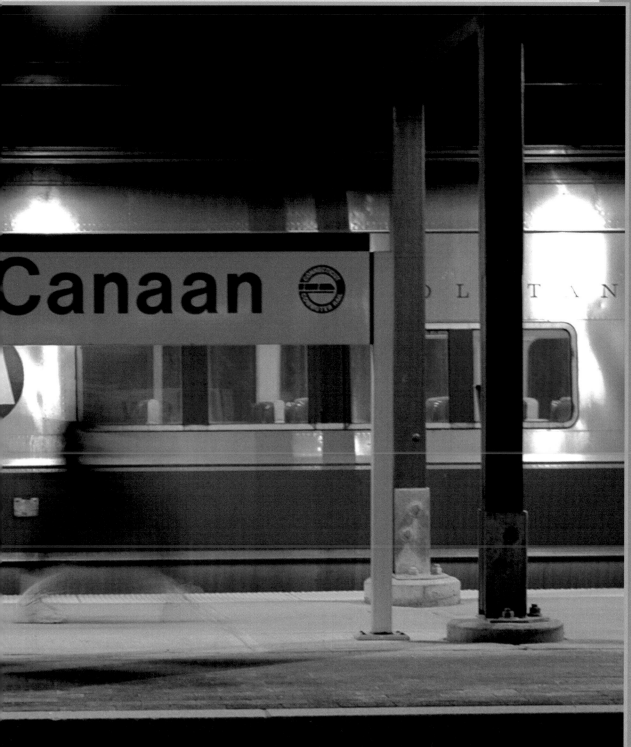

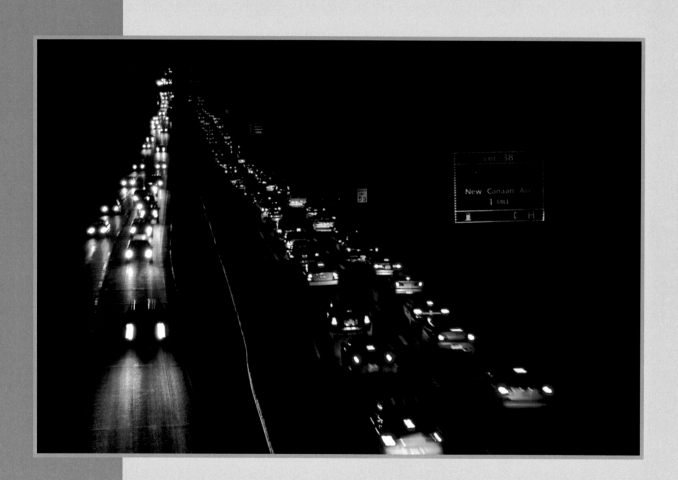

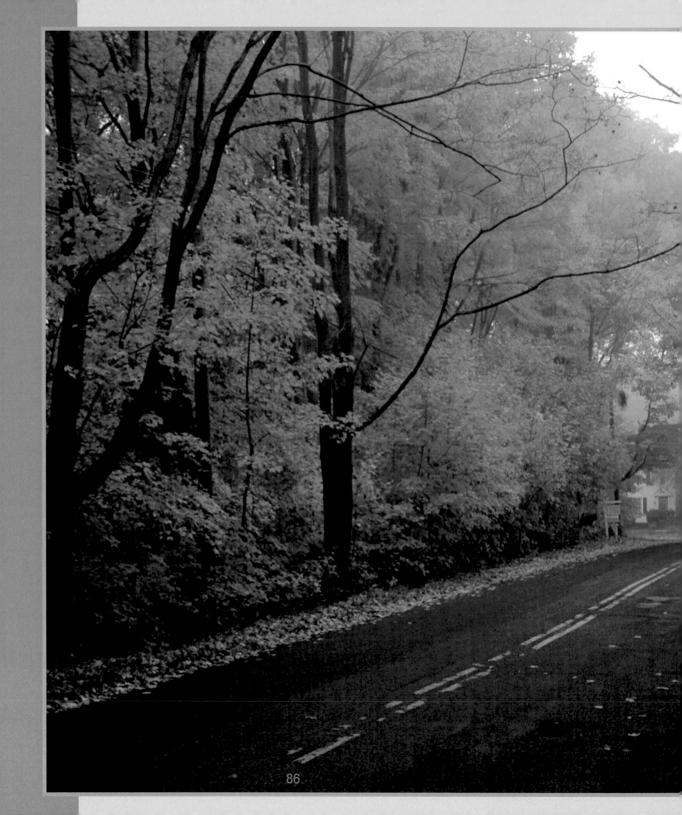

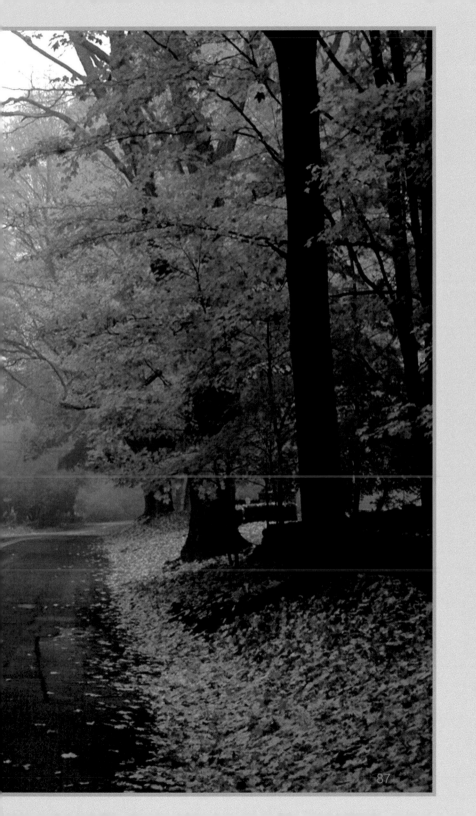

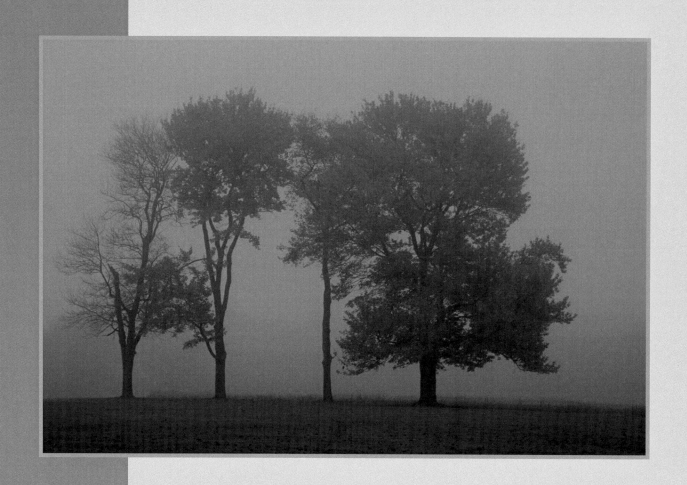

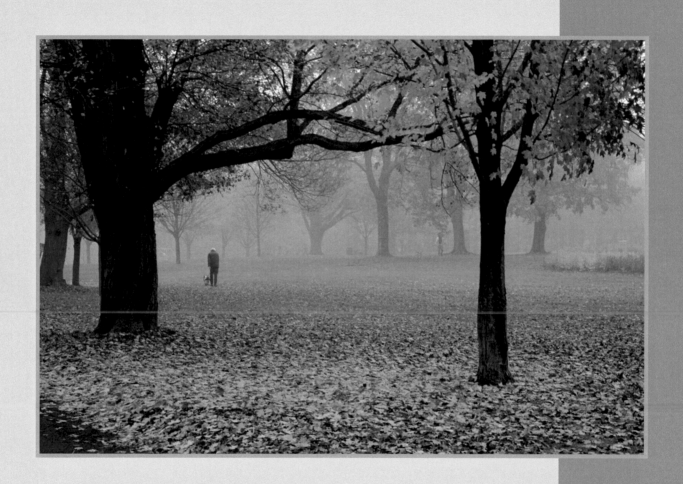

Contact Information:
For original photographs and gift items
please call 203-966-9422 or
Email: susan@susanmorrow.com